20 Years/20 Artists

This catalogue was published on the occasion of the exhibition *20 Years/20 Artists*, organized by the Aspen Art Museum. The exhibition was funded by the Aspen Art Museum National Council.

**20 years/20 Artists**
Copyright ©1999
Aspen Art Museum
590 North Mill Street
Aspen, Colorado 81611
970 925-8050

**Running Interference**
Copyright © 1999, Robert Hobbs

**Cover**
*detail*, Cindy Sherman, *Untitled #153 from the "Fairy Tales"* series, 1985

**Designer**
Jean Crutchfield

**Printer**
B & B Printing
888 224-2656
www.bbprintnet.com

ISBN 0-934324-26-3

Distributed by the University of Washington Press
P.O. Box 50096
Seattle, WA 98145

# 20 Years/20 Artists

Curated by Suzanne Feldman

Introduction by Suzanne Farver

Essay by Robert Hobbs

Aspen Art Museum

University of Washington Press

Seattle and London

## Acknowledgments

First and foremost, I would like to dedicate this catalogue to Suzanne Farver. Her quest for excellence has taken the Aspen Art Museum to new heights. Keeping in mind the diverse Aspen community, Ms. Farver has selected exhibitions which benefit the entire audience from important historical surveys to exhibitions featuring contemporary artists. Under her direction, and for the first time in its history, the Museum has achieved financial stability. It is because of Suzanne Farver's dedication and leadership that the Museum is in a position to move to the next level.

I would like to pay tribute to the artists. All of us are indebted to them for the richness they add to our lives.

My appreciation to the lenders who so generously loaned important works of art from their collections. I would also like to thank the galleries who represent the artists. Special thanks to the Aspen Art Museum National Council for funding the exhibition and to the Board for approving funds for the catalogue. In addition, I am grateful to the following individuals who went the extra mile in helping facilitate loans, offering advice and exchanging information: Howard Feldman, Toby Lewis, Dennis and Deborah Scholl, Ed Baynard, Judith B. Geller, Frannie Dittmer, Gael Neeson, Mary Boone, Leslie Cohen, Michael Jenkins, Tracy Williams, Nancy Magoon, Bob Gersh, Allison Feldman and Jess Feldman.

I want to thank Suzanne Farver, Executive Director of the Aspen Art Museum, for asking me to curate this landmark show. I also want to acknowledge the Museum staff for their invaluable assistance: Mary Ann Igna, Associate Director; Cath Murphy, Registrar; Meggan Humphrey, Public Relations Director; and Dana Geraghty, Exhibition Designer. Special thanks to Jean Crutchfield for the production of this catalogue.

I am particularly grateful to Robert Hobbs for his insightful historical essay.

Suzanne Feldman, Curator

# Contents

## Introduction and Historical Context
## Suzanne Farver

The inspiration for this exhibition stems from the twentieth anniversary of the founding of the Aspen Art Museum. We wanted to find a way to recognize the growth and maturation of the Museum over the past 20 years and also to recognize the changes in contemporary art over that same period.

We are greatly indebted to Suzanne Feldman for curating this exhibition. Through her own collecting and her experience in advising other collectors, she has gained a broad yet intimate knowledge of the contemporary art world. Her task was to select 20 artists who over the past 20 years have had the most impact on contemporary art.

This exhibition is also a tribute to those individuals who in 1979 had the strength and vision to form a world-class museum in a little ski town in Colorado. The groundwork for such an endeavor was laid by Walter and Elizabeth Paepcke with their formation of the Aspen Institute. The cultural environment in Aspen had already been established with the Aspen Music Festival and School. But there was little initial support from local government officials for a visual art center. We therefore have many people to thank for their efforts in organizing what is today one of Aspen's leading cultural institutions.

As I talked with some of the people who were involved with the formation of the Aspen Art Museum, I discovered a great passion for art and for the sharing of great art. There were three artists at the core of the idea: painter Dick Carter, sculptor Laura (Missie) Thorne and ceramic artist Diane Lewy. These three people above all others deserve our thanks for their many hours of planning, lobbying, cajoling and walking around with their hands out asking others to support the idea of a visual arts center in Aspen that would serve the community as well as bring museum-quality art to the rural Rocky Mountains.

Dick Carter remembers driving past the old Holy Cross Electric Company building every day as he traveled up Red Mountain Road to work for Herbert Bayer. When he found out the City of Aspen had plans to acquire the building, he

worked together with Missie Thorne and Diane Lewy to form a task force to build support for the idea of turning it into a center for visual art.

Dick remembers the initial political feedback as a challenge. There was one commissioner who said, "I wouldn't see another nickel of city funds go to fund a cocktail party for the Red Mountain crowd!" But that wasn't what these three were planning. They envisioned a community center, supported by local residents and artists, which would display a wide variety of art from contemporary to historical.

Missie Thorne recalls her early efforts to organize exhibitions of local and Colorado artists, scrambling for spaces and repainting walls in the Kresge Conference room at the Aspen Meadows in order to secure a space. She was elated at the prospect of a permanent location for the display of temporary exhibitions, and she started calling around the country to other art centers and museums to find out how to put a project like this together.

From the beginning, the idea was to create a center for the sharing of ideas generated from visual art of all kinds, from contemporary art to ancient artifacts. No permanent collection was planned, rather a rotating schedule of temporary exhibitions which would serve to educate our local community about quality art.

Janet Landry, then head of Colorado Mountain College, served as the chair of a community task force that researched the degree of local support for the

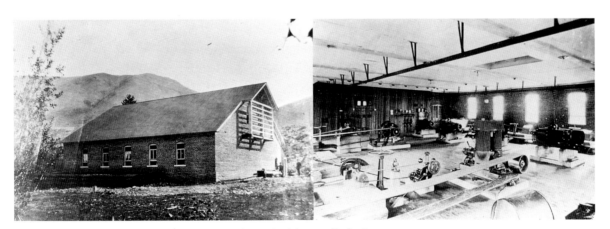

Aspen Art Museum "before"

idea and ultimately convinced the city council and county commissioners that this concept wasn't just a bunch of crazy artists with crazy ideas, and that it wasn't going to be just another place for rich people to have a cocktail party.

As Missie recalls, the focus from the beginning was to cover a broad area of the arts and to focus the energy on educational components. This idea found the grassroot support it needed, and the politicians finally were swayed.

The city council said yes, and even gave them money for development of the plans. It wasn't enough, however, and many other donations came in the form of materials, architectural advice, and individual grants. They searched for a director by calling everyone in the art world they could think of, and when Philip Yenawine came to town as a finalist it became clear that he was the person they needed.

Full of enthusiasm and with his heart clearly in the right place, Philip helped establish the Aspen Center for the Visual Arts as a real community locale. Fundraisers included the Art Cart Derby and wild Halloween parties (it was the early '80s in Aspen, after all). Exhibitions ran the gamut. The opening show was contemporary portraits and included works by nationally recognized artists as well as local painters. The next show was of medieval art from the Cloisters at the Metropolitan Museum.

Fundraising was a continuing challenge. Raising money for a fledgling organization with no track record meant finding people who were willing to take a chance. Philip Yenawine found housing from different folks around town and moved 13 times in his 3-year tenure.

In 1984 the name was changed to the Aspen Art Museum, and the vision for a world-class organization continued. Although support for the local artists' community was there from the inception and continues today with the annual Roaring Fork show, the founders wanted more than what the community artists could provide. For Philip, it was more than just educating the local school kids. It meant educating the board as well so they could better communicate the art that was being exhibited.

Philip began the Thursday evening gallery talks that remain today, and he encouraged school groups to visit – the genesis of today's Art Ambassador program

at the AAM, which pays for busloads of down-valley school children to visit our exhibitions.

Over the years the AAM has been served by many generous and capable people. We've been fortunate to have directors who followed Philip's vision – Laurel Jones, Annette Carlozzi, Susan Jackson and Susie Hojel, and also Margo Crutchfield and David Floria, who served as both curators and interim directors. Our board presidents have given from their hearts as well as their bank accounts – Missie Thorne, Marty Kahn, Laura Donnelley, Mary Jane Garth, Diane Anderson, Merrill Ford, Roberta Allen, Alan Marcus, Dick Osur and current president Susan Marx. We thank these people as well as the many other board members, National Council members, volunteers and supporters who have made the AAM a vital ingredient in the rich cultural fabric of this vibrant community. We are fortunate to have generous support from people both inside and outside this valley, but we continue to serve this valley – over two-thirds of our members call the Roaring Fork Valley their home.

It has been a privilege for me to serve as Executive Director for these past seven years. I have grown immeasurably from the experience, and the AAM has grown as well. Our budget has doubled, and our support groups are thriving. Exhibitions continue to be varied, and our educational programming has expanded to include children from throughout the valley. Howl at the Moon has replaced Halloween, but the fun is still there.

I hope this exhibition creates a spark of reminiscence as well as a seed of thought for the future of the visual arts in this community. The AAM has become a strong and viable institution. It deserves our enthusiasm, respect and continued support.

*Suzanne Farver is the Executive Director of the Aspen Art Museum.*

## 20 Years/20 Artists: An Introduction
## Suzanne Feldman

20 Years/20 Artists is a commemorative exhibition celebrating the twentieth anniversary of the Aspen Art Museum. The exhibition features 20 artists who emerged during the last 20 years and have made significant contributions in photography, painting, film and sculpture. In a broader context, this show cross-references the parallel paths of the struggles and achievements of the Museum and the artists over the past two decades.

To attempt to define a time frame through 20 artists is a slippery slope, and it should be said from the onset that the artists selected represent a curatorial perspective within the parameters of a 20-year theme. Consequently, there are many artists missing. In addition, this is an "of the moment" assessment, as it is too soon to place artists of the eighties and especially the nineties in a definitive art historical context. After all, the significance of Warhol and de Kooning have only recently been fully realized. Even their achievements will take on different meanings in the years to come.

The exhibition is loosely chronological. The artists mirror the decade, not specific years. Representing the 1980s are Jean-Michel Basquiat, Francesco Clemente, Eric Fischl, Julio Galán, Robert Gober, Mike Kelley, Jeff Koons, Charles Ray, David Salle, Julian Schnabel, Cindy Sherman, Jeff Wall and Terry Winters. The 1990s are represented by Matthew Barney, Andreas Gursky, Damien Hirst, Juan Muñoz, Kiki Smith, Kara Walker and Rachel Whiteread. Since the artists are only represented by one work of art, I have chosen the works very carefully, selecting seminal works and iconographic images like Koons' *Rabbit* (plate 9), 1986, and Gober's *Long Sink* (plate 8), 1985, which best exemplify their oeuvre.

Within the context of this introduction, it would be impossible to discuss in detail the specific intentions of every artist in this exhibition. What I want to call attention to are the overall influences and precepts which connect the dots of issues and concerns that link the 20 artists together while pairing the Museum and

the artists in relation to their shared objectives.

Undoubtedly, the single biggest influence on the artists of the past two decades has been conceptual art. With its origins in Marcel Duchamp's "ready-mades," conceptual art turned away from the traditional tangible object as art, substituting ideas in the format of photocopied documents, alterations to nature, mathematical formulas, text and language drawn on walls, film and performance. By the 1980s, confined by the limits of conceptualism, the artists returned to the object, this time ascribing a specific narrative context expanding the Dada tradition of "art is what I say it is" by adding "and this is what I say it means."

In the 1990s, another shift occurred. Rather than focus on a specific piece or image, the artists turned to installations, assembling and arranging materials in open space to create personal and fictionalized narratives. In Mike Kelley's *Arena #7*, 1990, (plate 10) the found stuffed animals seated around a blanket suggest a pastoral family picnic but are intended as a mockery of the perceptions of family and rituals, while on another level the dirty, throw-away toys express child abuse and parental neglect.

The threads which link all of these artists together are the issues of identity – with the self, mass culture, AIDS, mortality, gender, race, feminism, masculinity, adolescence, stereotypes, social behavior and taboos. Two artists in the exhibition, Cindy Sherman and Rachel Whiteread, explore identity issues from different points of view. Masking her own identity with disguises, Cindy Sherman portrays women in stereotypical feminine roles. Although ambiguous, these staged photographic narratives evoke a psychological association with feminine vulnerability. Rachel Whiteread utilizes furnishings and hardware as a metaphor for human beings. Casting the inside of the object in plaster or resin, she exposes the private inner self by turning the inside out. Conversely, what once was the shell, now becomes buried within, returned to the safety of the womb.

It is within the context of this investigation of identity that the parallel paths of the Aspen Art Museum and the artists converge. Like the artists who are fueled by questions of meaning and relevance, the Museum must also continually

reassess who it is through its mission and purpose. The artists who founded the Museum envisioned it as a place for local artists like themselves to exhibit art and exchange ideas within the context of a broad-based, major exhibition program. Over the years, with the help of generous supporters, this mission has continued to include national and international exhibitions and programs for adults and children, making the Museum a vital year-round cultural resource for the region.

Indeed, this evaluation of the last 20 years is at best an overview. Critical analysis is an ongoing process, and what seems certain now will change in the years to come. Time will be the ultimate judge. For the significance of an artist's work lies in the ability to communicate, not only today, but throughout the centuries.

*Suzanne Feldman is the curator of this exhibition.*

# Running Interference
## Robert Hobbs

"Running Interference," a term used for offensive plays in football in which guards and often fullbacks clear paths for plays to be made and yardage gained, is a useful analogy for the goals of recent art. Instead of attempting to replicate external reality, this recent work appreciates the obstacles that make such an idealistic quest an impossibility. We might say that the overall aim of this art is to focus on an aesthetic interference and to emphasize those elements overtaking the role of direct communication such as acknowledged ideological constructs, mass-media imagery, the citation of particular genres, and discourses.

There are a number of precedents for this attitude, including contemporary linguistics and the art of both John Cage and Andy Warhol. Prior to the 1960s, linguists posited ideal channels of communication in which messages were unmediated by misunderstandings. They ignored the general cultural noise that interferes with the original intent of communiqués. Slowly, however, they became aware that there are no ideal speaker/listener situations and no totally homogeneous communities ensuring perfect communication.

These conclusions were anticipated by Cage in *Imaginary Landscape No. 4*, 1952, a four minute piece for twelve radios, with two people assigned to each radio: one was instructed to operate at will the dial determining the choice of stations while the other, acting independently, was to control volume and tone. The resulting piece of music accorded with a goal set by Cage in a 1937 lecture. "I believe," Cage said, "that the use of noise to make music will continue and increase until we reach a music produced through the aid of electrical instruments which will make available for musical purposes any and all sounds that can be heard."[1]

Cage's penchant for courting the impediments of sound as a means for bringing viewers closer to the actuality of life – a goal which he later ascribed to his study of Zen – was a crucial factor in Warhol's silkscreens in which the seemingly careless printing of colors off register created powerful images of individuals subsumed by mass media. His works dramatized the force of Marshall McLuhan's

contemporaneous meditations on the effects of such media:

> *In a culture like ours, long accustomed to splitting and dividing all things as*
> *a means of control, it is sometimes a bit of a shock to be reminded that, in*
> *operational and practical fact, the medium is the message. This is merely to*
> *say that the personal and social consequences of any medium – that is, of any*
> *extension of ourselves – result from the new scale that is introduced into our*
> *affairs by each extension of ourselves, or by any new technology.*[2]

These forays in the realm of interference have become increasingly important. In the late 1960s a crucial change in the understanding of the interrelationships between people and their culture occurred when theorists no longer tried to relate their findings back to an autonomous human being but instead found humans to be socially constructed through the dominant media used and the subsequent culture created. At this point, people were no longer regarded as predetermined essences whose life's project was self-discovery. Instead, the self itself was viewed as an ideology predicated on a nineteenth-century bourgeois definition of individuality. Of particular significance to this major shift in perception are the ideas of French post-structuralist critic Jacques Derrida. In his early publication *Of Grammatology*, 1968, he described the necessary delays in communication that problematize direct transcriptions of meaning, causing crucial terms to be placed under erasure so that they are acknowledged as historically significant even as they are denied universal application. Derrida has traced his lineage to the language studies of German phenomenologist Martin Heidegger who placed terms such as "being" and "God" under erasure and who stressed humanity as a creation of language rather than vice versa. In addition Derrida sided with the slightly older French theorist Roland Barthes who described the dissolution of the traditional author's autonomy as a recognition of genre's power. In other words, authors are constructs dependent on the specific requirements of such genres as the novel, the sonnet, the lyric poem, etc. Going much further than Barthes, Derrida in *Of Grammatology* analyzed the conventions on which the eighteenth-century writer Jean Jacques Rousseau depended, showing in the process how they represent unresolved contradictions.[3] Then Derrida used these incongruities to deconstruct Rousseau's main arguments.

He concluded that Rousseau himself is a product of his text rather than its initiator and the outcome of a series of misaligned conventions rather than their creator.

For artists working in the late twentieth century Derrida's thought has had profound and wide-sweeping ramifications since it undermined the formerly accepted romantic role assigned artists as demigods capable of creating worlds and conveying their most private feelings in their work. Both products of their time and articulators of established languages rather than their originators, artists have had to settle for less elevated roles. But their compensation has been the opportunity to assume the far more direct and relevant position of appraising given genres and established conventions as necessary forms of mediation through which a culture constructs itself. The following analyses of the artistic sensibilities represented in this exhibition are intended to demonstrate how the utilization of social languages manifests itself in this new work and how these attitudes are running interference, or, "drawing restraint" to employ a term used by one of the exhibition's artists, Matthew Barney, who created in his early works such resistant forces as encumbering rubber cords so that the act of drawing would become as difficult as possible.

## Cindy Sherman

Behind every Cindy Sherman persona is the allusion of a healthy American woman cultivating a mask, playing a game, and assuming a posture. But after looking at a great number of her photographs, the illusion that behind every mask dwells a well-integrated and monolithic individual ready to be unveiled by discriminating viewers begins to appear as much a myth as the many guises that the artist assumes. One suspects without being able to prove it that the real Cindy Sherman is a fabrication too, another culturally constructed figure necessary for the smooth operation of this work. To appreciate the significance of this hovering persona behind the mask, we need to ask what would happen if there were no centralizing force holding together this body of work. At this point the phrase "body of work" breaks apart as Sherman's generative pun regarding her polyvalent corpus is recognized and redeemed: reality is masked both in the art and in the offstage

figure of a chimerical artist who is revealed as a socially accepted convention for anchoring a collection of disparate images.

## Francesco Clemente

Although Francesco Clemente appears to be obsessed with himself or at least his self image, he permits himself in his art the role of the seducer who is captivated by images of his ongoing metamorphosis. If the self is merely a construct, as most postmodernists contend, then Clemente has enlisted a range of historical artifices to create a transcultural, transhistorical, and transavantgard migrating self. A seemingly endless series of hothouse hybrids, Clemente's many visages recall the arcane perversity and giddy decadence of Salvador Dalí, similarly leaving one with a question that will be long debated: do Clemente's erudite artifices enrich our understanding of polymorphous perversity in the late twentieth century or merely complicate and accessorize them?

## Eric Fischl

When his first mature works appeared, Fischl seemed to have found a visual means for discerning the moral issues of a post-Freudian age. After decades of analysis augmented with numerous pop therapies, suburbanites in the United States in the 1950s and 1960s – the era of Fischl's childhood – seemed at last to have let go of their inhibitions and anxieties. They seemed to have settled on a position of willed openness capable of driving out or at least quelling the most recalcitrant demons that could issue forth from the unconscious.

However, Fischl's faux naive manner of painting, which unfortunately connoted only technical incompetence to conservative critics, has served his art well by complicating his narratives, endowing them with an insidious irony that keeps easy moral conclusions at bay. Instead of putting viewers at ease by castigating a world of far too easy virtue, his technique had the opposite effect of making the ethical component of his paintings appear too pat, too similar to the staged soap

opera dilemmas appearing daily on national television that assuage and comfort more than they disturb. Instead of providing tableaux that we might objectively judge, he inveigles viewers into looking at his constructed narratives, turning them into voyeurs and thus posing the more provocative question of why they enjoy looking at these scenes and are willing to enter into tacit complicity with their protagonists.

## Jean-Michel Basquiat

If we attempt to find clues to Basquiat's inner essence in his completed paintings, we may well find ourselves frustrated in the attempt, for this artist joins a streetwise forthrightness and an expert graffiti artist's ability to collaborate with flat urban spaces with the insouciance of Larry Rivers and the finesse of Willem de Kooning. His art mixes genres, and in the process it colonizes both street art and aspects of the New York School.

In terms of a tradition, Basquiat's can most closely be grouped with the contrapuntal work of David Salle and Julian Schnabel, who both owe an aesthetic debt to German artist Sigmar Polke. Although it also takes from Rivers and de Kooning, Basquiat's art is less involved with their jazz-era tendency to improvise than it is with the postmodern conception of art as a momentary ordering of both aligned and nonaligned codes (think of Derrida) that we choose to read as aesthetic wholes. Whether he is ironic or co-opted, whether he is using primitivism or is a genuine industrial folk artist, and whether he wishes to critique the white art world or merely be accepted by it are questions that cannot be readily answered since his art is predicated on the uneasy, yet potent coexistence of disparate genres.

## Terry Winters

The botanical and mineral references found in Terry Winters' paintings would lead one to expect a reposition of the primacy of nature as the artist's proposed subject. But the insistence with which they are painted and the off-hand, seemingly casual

compositions in which they are organized all point away from the work and in the direction of the artist as a distinct and special sensibility capable of distilling and reframing nature into an extension of himself. However, this conclusion is soon thwarted when one recognizes the intertextuality at play that connects these works with notebooks of romantic naturalists, scientific diagrams of bisected and dismembered life forms, and microscopic images of cellular forms. Winters counters the personal with the scientific, pitting remnants of a pastoral tradition with cool objectivity. Observers are invited to look contrapuntally, alternatively using the lens of romantic sensitivity and scientific detachment to discern traces of each in the completed work.

## David Salle

In David Salle's work the two key postmodern strategies of appropriation and intertextuality reinforce a new way of conceiving art in terms of past work so that influences are not just admitted, they are in fact encouraged. Appropriation signals an informed act of borrowing so that the former use to which a given image has been subjected is sustained, creating tensions between old and new contexts. In Salle's paintings and assemblages this tension is maintained in his choice of soft porn images and references to such earlier artistic styles as minimalism, turn-of-the-century illustrations, constructivism, and expressionism. Rather than attempting to attain closure in his art, he aims to sustain as much openness as possible so that it maintains its viability as a perpetual tug-of-war between high and commercial art, propriety and vulgarity.

Working in tandem with appropriation and definitely related to it is intertextuality. This strategy enables viewers to see one work of art through another in much the same fashion that people in the eighteenth and nineteenth centuries might have looked at a landscape with a Claudian glass, which would have darkened it, endowing it with old master status. In Salle's work this mode of looking is evident in his references to 1950s design, which causes the present to be read in terms of the past, much as the film *Blade Runner* is narrated in the manner of a 1940s film noir hero who turns the future into an antiquated vision.

## Julian Schnabel

In the early 1980s painted portraits were anachronisms suitable for regional gentry who applied to such places as Portraits Incorporated in New York or local practitioners content to paint in a *retardataire* manner. Although such important photographers as Robert Mapplethorpe consented to work in this genre and pop artist Andy Warhol toyed with its high fashion and *ancien regime* connotations by turning portrait painting into a thriving business, few painters were as intrepid as Julian Schnabel when he undertook a series of plate-painted portraits. In *Ross*, no doubt intended as an image of Schnabel's contemporary, the artist Ross Bleckner, we find heightened to an extreme the bifurcation of realism important to the mid-nineteenth century painter Gustave Courbet. Whereas Courbet felt the necessity to acknowledge and ameliorate the two realisms of external reality (imitation) while acknowledging the limitations and importance of his medium (representation), Schnabel placed the two in fierce competition, forcing viewers to hazard the obfuscatory broken crockery that shatters the image of Ross Bleckner at the same time that this collection of shards supports it. Even though one achieves, after a moment of initial hesitancy, the goal of seeing the depicted face of this painter, Schnabel's interference caused by the broken plates keeps reasserting and insinuating itself, making certain that its blockage becomes part of the work's content.

## Robert Gober

As much as we might wish to make Gober's sinks into surrogate beings, they remain sinks – not simulacra of sinks as they have been termed in the past, but their handmade copies – without plumbing and therefore without function, reduced to the level of an inert object and simultaneously elevated to the category of art. In their emptiness is to be found their pathos, and in their laborious hand-made fabrication is to be found their critique of the industrialism that Duchamp's readymades readily acknowledge and minimalist sculpture seems to celebrate. We might term Gober's sinks, "readymades remade," and laboriously so, creating a space between themselves and their mass-produced counterparts – a quiet requiem

for the handmade which approaches the perfection of the mass-produced object without being able to emulate it.

## Jeff Koons

When modernist critic Clement Greenberg assembled in 1961 a collection of his writings for Beacon Press under the title *Art and Culture*, he included as his first selection the 1939 essay "Avant-Garde and Kitsch." Probably the reason for this choice is that this essay permitted him the opportunity to establish at once the polarities of avant-gardism and kitsch and to assume the aristocratic point of view of the former by characterizing the latter as a rear-guard pandering to the masses. His characterization of this mass sensibility as corrupt is worth recounting:

> *Kitsch, using for raw material the debased and academicized simulacra of genuine culture, welcomes and cultivates this insensibility. It is the source of its profits. Kitsch is mechanical and operates by formulas. Kitsch is vicarious experience and faked sensations. Kitsch changes according to style, but remains always the same. Kitsch is the epitome of all that is spurious in the life of our times. Kitsch pretends to demand nothing of its customers except their money — not even their time.[4]*

Greenberg's piece was written at a time when the United States was still suffering from the Depression, federal support for the arts was resulting in few truly outstanding projects, Stalin was being revealed as a despot, and an idealistic Trotsky was writing in exile that artists must remain true to their own vision because the socialist state needed their independence in order to keep it honest and on track. At this time an innovative leftist critic such as Greenberg could conceive kitsch as the enemy because it attempted to reduce art to the lowest common denominator of intelligibility to an uneducated working class who might possibly form an eventual proletariat. For Greenberg its problem lay in its inability to perpetuate an elitist position and thereby raise the proletariat to a new and higher level.

While Greenberg's political agenda is understandable within the context of his times, it severely curtails our present understanding of kitsch and thereby

impoverishes an urban vernacular sensibility deserving recognition. There is sufficient evidence to make the claim that kitsch replaced the folk culture that a rural bourgeois culture lost when it became urbanized and that kitsch can be regarded positively as well as negatively.

One of Jeff Koons' major contributions is his recognition of the strength and endurance of this industrial-era aesthetic. His approach has little in common with elitists who might embrace kitsch as a mode of cultural critique or irony. Instead, he looks at it as a form of taste that might be banal but is still revered by people who often occupy the lowest economic levels. When he integrates the scale and materials of high art, together with its placement on pedestals in pristine white art galleries, with low art subjects in his Statuary series, for example, the results are refreshing. His *Rabbit* (plate 9) calls to mind Brancusi's *Bird in Flight*, without compromising the naïveté and irrepressible ebullience of the original inflatable toy which the artist had cast in stainless steel, a material he has termed "proletariat silver."[5] Breaking with Greenberg's academic vanguard in his conjunction of modernist and kitsch genres in this piece, Koons both supports and undermines McLuhan's "medium is the message" dictum. In this work Koons' interference is double valenced, for it pits high against low, and rear guard against avant guard.

## Mike Kelley

While Koons invokes kitsch, Kelley often dramatizes it in his early work by setting up situations in which stuffed animals become surrogates for the missing adults who made them and the children who once played with them. "I don't think that I'm much involved with kitsch," Kelley has stated. But contradicting himself, he has also said, "I'm involved with using popular language because it is a commonly understood one."[6]

When he began, this Los Angeles based artist intended first to critique feminists who essentialized womanhood by embracing culturally conditioned practices such as sewing and knitting. Seeing no reason why these pursuits should be regarded as solely feminine, Kelley worked with castoff crocheted afghans and

stuffed animals. He has intended these works to function in a social realm rather than a personal one, commenting, "The stuffed animal is a pseudo-child, a cutified sexless being which represents the adult's perfect model of a child – a neutered pet."[7] To avoid falling into the trap of subscribing to the values usually associated with these winsome creatures, Kelley chose abandoned toys, pathetic in their abjectness with enough of a scruffy edge to keep them from being read as merely sentimental reflections of an idealized childhood. In their abjection they bespeak a loss of innocence.

## Charles Ray

Enlarging the divide between art and life and working in this highly ambiguous realm is an ongoing goal of Charles Ray's work. In *No* (plate 11) made in response to *Yes*, a convex photograph of himself made while under the influence of LSD, Ray first had a fiberglass body mold of his head and hands made and then had it painted to resemble him. This facsimile became the subject of Ray's *No*, a photograph of his surrogate.

In *No* Ray reverses the process initiated in the late 1960s by the conceptually oriented photo realist Chuck Close, who makes detailed paintings of snapshots to underscore the disparity between photographic and external reality. Rather than using art as an empirical means for understanding the world, Ray employs it as a symbolic mode to dissimulate and confound and also to construct and replace those elements we are accustomed to accept as real.

## Kiki Smith

Among the artists in this exhibition, Kiki Smith comes closest to essentializing the self through her investigations of the body's internal systems. She appears to be looking for a substratum of authenticity on which to base all experience and finds it in the body, which to her is a sine qua non for a sculptural space, which is internal as opposed to external and suggestively feminist in orientation. Even though Smith

and her associates have protested that she is not political, she seems definitely to be involved with a feminist oriented politics of the body and the battle over who controls it.

Although she searches for a commonality of human experience in her art, Smith is not entirely out of kilter with her postmodern times since the bodies she portrays are categorical rather than individual, disparate parts rather than cohesive entities, and representatives of the species rather than family members, friends, or associates. They are both distant and near and scientific as well as highly personal. Her sculpted delegates of the human race are generally found in the abject circumstances of losing control over their perimeters, dispersing into separate parts, or seen as *écorché*, flayed anatomies.

## Julio Galán

Viewing himself as other, as feminized self-portrait, and as a devotional image, Mexican artist Julio Galán captures traces of selfhood that are reassembled in wonderfully decadent confabulations which deconstruct the conventions of the individuality that they so playfully and eruditely produce. Instead of manifesting a believable self, his works resist this psychological truism as a no longer viable myth and opt instead for the trimmings of pageantry, grandeur, folk references, kitsch appurtenances, vanguard allusions, and regionalist flavors. The dialects are many and the intonations are varied, but the overall effects are as international as the Monterrey and New York locales where the artist has lived. The closer that the self is brought to front stage center in Galán's work, the more exotic, polyvalent, and elusive it becomes.

## Jeff Wall

Wall's carefully composed and reworked images cast doubt on the verifiability of photographs, causing one to question the self-evident truth and often ubiquitous reality they purport to represent. Through careful composing and computer

enhancement, Wall reworks and edits the external world, placing it under erasure so that it seems to be both affirmed and subjected to change.

Wall, a Vancouver-based former conceptualist, models his art on the modernist painting of Edouard Manet and on cinema. Wall speculates about how Manet in the mid-nineteenth century was positioned at a crossroads in which progressive painting soon closed off viable arenas of investigation such as photography as it moved in the direction of abstraction. Wishing to reenact this seminal juncture, Wall joins in his highly controlled images aspects of painting, cinema, and photography.

Although Wall strongly disclaims any association between his lightboxes and those used for advertising, his works do rely on this highly viable commercial medium that lends a healthy brashness and temporality to his long-considered images, making them appear both timely and immediate. In addition, this connection with the marketplace endows them with the authority of a corporate production, causing observers to consider them as specific communiqués. In this way, Wall can play with viewers' expectations and create tensions by purposefully avoiding easy conclusions.

## Damien Hirst

The German philosopher Martin Heidegger believed people must counter the accidental nature of their birth and the world view it entails by coming to terms with the inevitability of their death, for only when they perceive their own ultimate end are they equipped to lead an authentic existence. But coming to terms with this great hiatus may be easier to speculate about than to realize as Damien Hirst's works forcefully suggest.

A British artist coping with his Catholic upbringing and the great divide separating life from death, Hirst provides provocative images of death in the form of rotting flesh, maggots, dying butterflies, and sawed-in-half dead animals. Because the moment of self-realization described by Heidegger must be personally intuited and accepted, Hirst's sculptures and tableaux can only present viewers

with the finality of death as an aesthetic fact that is both mystifying and intriguing and surprisingly never as horrific as one might imagine. It is the facticity of death that becomes his subject, and it remains inexplicable. As Hirst pointed out, "Trying to explain or imagine death is like trying to imagine black by only using white. There's no way you can get to it, it's like the same thing but opposite. This is life and death isn't. I'm not happy with any of those descriptions."[8]

Although he describes his work in terms of traditional metaphors, he admits their limitations in the face of the sheer brute reality that is part of life itself as his explication of *Party Time* (plate 15), an enlarged ashtray indicates:

> *The whole smoking thing is like a mini life cycle. For me the cigarette can stand for life, the packet with its possible cigarettes stands for birth, the lighter can signify God which gives life to the whole situation, the ashtray represents death. But as soon as you read it like that you feel ridiculous. Because I feel ridiculous being metaphorical anyway, but it's unavoidable....Ashtrays are like holes in our everyday situation and these holes get smaller and smaller but never actually disappear.[9]*

## Kara Walker

In the 1990s a number of African-American self-taught and educated artists, including Thornton Dial, Ellen Gallagher, Bessie Harvey, Glenn Ligon, Lonny Holley, Gary Simmons, Kara Walker, and Fred Wilson, inaugurated a new phase of the civil rights movement when they began to appropriate derogatory Jim Crow era stereotypes in their work. They have permitted their work to engage in the tensions ensuing from the diametrically different world views of the post-slavery and post-Civil Rights eras. These artists have hazarded such an undertaking because of their belief that repressed racist imagery will only lose its horrendous power when it becomes part of an ongoing discussion about discrimination in the United States. Surprisingly their imagery has threatened an earlier generation of African-American artists who wished to support only positive role models. When members of this earlier generation used such racial stereotypes as Aunt Jemima,

they empowered them. But working with such innocuous material as Aunt Jemima has not impressed artists coming of age in the 1990s who have wanted to confront more challenging issues and far more disturbing images.

Of all the 1990s African-Americans working with stereotypical imagery, Kara Walker has proven to be the most controversial. An acrimonious debate has developed from a constellation of factors, including Walker's being awarded the MacArthur "genius award" only a few years after graduating from the Rhode Island School of Design, and her uninhibited cut outs of silhouetted figures in Victorian period dress conducting a range of sexual acts and bodily functions that include sodomy and defecating. The major criticism lobbed at her work by Betye Saar and others is that her demeaning images of blacks have fed the racial prejudices of white collectors.

More to the point Walker has found that the medium of silhouetting, with its obvious allusions to shadows and its underexamined overtones of constituting two-dimensional caricatures of a three-dimensional humanity, comprises an incisive critique of the stereotypes presented in her work. She equates silhouettes with stereotypes because each "says a lot with very little information."[10] In addition, she sustains the recent tradition of dealing with negative forms of blackness that gives a decisive edge to the fiction of Toni Morrison and Alice Walker, the comedy routines of Eddie Murphy, and the films of Spike Lee. She has noted that when she developed a format of monumental silhouettes for her work she "was thinking about blackness, and minstrelsy, and the kind of positions that I was putting myself in at home in Atlanta."[11]

Part of Walker's quest in making these tough works of art is to understand how racist practices stretching back to the nineteenth century have affected her life. "I saw myself as someone who was locked in histories, as a nebulous, shadowy character from a romance novel," she has related, "but not a novel that anyone ever remembered."[12] On another occasion, she remarked,

> At some point in my adventures I stored up some self-abusive language, and the term "black hole" kind of stuck. It's a little bit loaded, I guess — it's sexually and racially obscene, it's a frightening astronomical phenomenon, it's what you get when you cut black paper...all that in such a benign little craft.[13]

In her work, humor is both a double-edged tool that uproots long sequestered imagery at the same time that it redirects the brunt of racist jokes so that their target is no longer assured. As Walker has concluded, "I use humor, but a type of humor that makes it difficult for myself or a viewer to decide just how hard to laugh. That uneasiness is an important part of the work."[14] In *De Flower of Georgia* (plate 16) an ambivalent punch line is apparent in the reference to a tree of life, taking the form of a sapling that winds through a young girl's body, becoming an anchor, a prison, an invader, and an instrument for deflowering and impregnating her.

## Juan Muñoz

Muñoz's view of humanity at the end of the twentieth century is a vastly impoverished one that can easily be replaced by dolls, mannequins, and ventriloquists' dummies. In his effort to uphold this abiding metaphor of a humanity realizing far less than its potential, he treads close to violating political correctness standards when he references dwarfs, disfigured figures, and traditionally dressed Chinese greatly reduced in both height and stature. But since art often functions in a manner akin to dreams by disregarding daily standards in an effort to shock, Muñoz's transgression of highly sensitive issues can be understood as an aesthetic device even if it cannot be entirely condoned. His apparent message is that ensconced traditions and accidents of physiognomy can be used to symbolize the ways that modern humanity has allowed itself to be unnecessarily encumbered and reduced.

## Matthew Barney

Performance artist, filmmaker, sculptor, and draughtsman, Matthew Barney is now concluding the fourth of his five proposed *Cremaster* films. Not made in consecutive order, these highly fanciful extravaganzas provide a vision of humanity at the dawning of a new age. Named for the cremaster muscle that determines sex differentiation in the fetus through ascent in the female and descent in the male, Barney's series appears to be concerned with gender issues. But according to the artist, his intentions

extend beyond such localized debates, "I'm less interested in the external debate about gender, which I don't think my work is about. It's more about the endless possibilities this organism can take on, the fact that it can occupy a field that is designated as feminine or masculine or androgynous, but I'm not more interested in one than another."[15] This fascination with the potentialities of humanity to deal with vastly different types of restraints may be a reason why Barney is intrigued with the Victorian magician Harry Houdini, who was able to disentangle himself from locks, straightjackets, and caskets.

In *Cremaster 1*, the second film to be completed in the series, Barney situates his work in a football stadium located in Boise, Idaho, his home town. The film suggests a cause and effect relationship between a female character named "Ms. Goodyear," seated beneath a table in a dirigible, who configures grapes in a variety of formations recalling the female reproductive system while eighty cheer-leaders in sci-fi outfits with plastic helmets enact these positions on a playing field of blue astroturf. Simultaneously working through these positions, these figures recall the optimism of early Busby Berkeley films when the smooth and extravagant choreography of multitudes of showgirls on an extended stage seemed to symbolize the well oiled machinery of the streamlined era to which this filmmaker belonged. This misplaced optimism and its highly artificial dream effects seem to comment on elaborately contrived ideologies of the 1930s that were able to subjugate women into assuming mere decorative roles. After Ms. Goodyear descends to earth (plate 18), the entire ensemble gathers in a grand paean to traditional, Hollywood-style femininity.

When Barney frames the stills for this film in a self-lubricating and frictionless plastic identical to Teflon (which he does for most of his film stills), he uses a material readily "accepted by the body."[16] This material heightens the irony of his film since it implies that not only the frame but also the work of art it surrounds can be internalized as part of humanities' vision of itself. As Barney explained apropos his early drawings that were framed with a prosthetic plastic which he later replaced with a self-lubricating variety, "The drawings became an internal space that a prosthetic orifice opened up to reveal."[17] Although Barney

presents images of traditional femininity in *Cremaster 1*, his intent is not simply to use it ironically to support a feminist party line. Instead of championing gender politics, his art in this film, as in his others, is to point to internalized restraints – ideologies, that entertain and beguile even as they seduce humanity with the apparent naturalness of their highly artificial visions.

## Andreas Gursky

In his monumental photographs Andreas Gursky presents images of humanity caught up in forces far greater than the capacity of any single individual to alter them. They range from such mundane activities as swimming, skiing, May Day celebrations, and stock brokers carrying out their daily activities to landscapes bearing the marks of civilizations. The omniscient view that might have represented an offstage narrator or idealized artist in former times is limited in Gursky's art to the wide-angle lens of an elevated camera. And the concomitant sublimity of a transcendent experience veers away from the romanticism of a Caspar David Friedrich painting in which individual power is extolled. Instead of elevating individuals, Gursky's images reduce them to patterns, mere cogs in a vast machinery that can alter them as easily as the artist can rework the pixels on his computer software and thus edit his photographic images of the world.

To appreciate Gursky's ambitions it is necessary to understand his participation in a particularly vital artistic community located both in and around Cologne and Düsseldorf that includes his teachers, the minimal documentary photographers Bernd and Hilla Becher, his classmate Thomas Struth, and a number of luminaries who once contributed to its vitality such as Joseph Beuys and Anselm Kiefer. His ambition is nothing less than the task of critiquing the romantic tradition which was initiated in late eighteenth- and early nineteenth-century Germany before it became an international phenomenon and encouraged other countries to espouse beliefs in a secularized God, a spiritualized nature, and their individual country's destiny. To counteract this, Gursky has chosen to photograph nature schematized, bounded by pavement, reduced to patches of weeds, artificially

constructed as massive gardens atop buildings in Hong Kong (which itself is a highly artificial political entity), and subdivided and parceled out in utopian architectural projects gone awry and reduced to the barricades of cell-like blocks. His images of power focus on its dispersal in a series of incredibly large and immaculate factory interiors and in his views of stock exchanges in both Hong Kong and Chicago where an individual's sovereignty is reduced to that of an automaton or a crowd member.

## Rachel Whiteread

Whiteread's reputation was established overnight by the critical acclaim accorded her 1993 *House*, a concrete casting of the interior of an entire three-story row house in a working-class section of London slated for demolition and urban renewal. Since then she has become respected for the poetic evocations of absence created by her castings of usually the negative spaces formed by bathtubs, beds, chairs, morgue slabs, books, and floors. Although ostensibly owing a debt to such works by Bruce Nauman as *A Cast of the Space Under My Chair*, 1965-1968, Whiteread's sculptures in plaster, rubber, polyester resin, and now aluminum and bronze, which evoke internal forgotten and derogated areas, can be aligned with the aspirations of feminists who wish to understand internal as opposed to external spaces and who externalize them in order to know them.

*Dr. Robert Hobbs holds the Rhoda Thalhimer Endowed Chair of Art History, Virginia Commonwealth University.*

## Endnotes

1. Calvin Tomkins, *The Bride and the Bachelors* (Harmondsworth, England: Penguin Books Ltd., 1976), 87.

2. Marshall McLuhan, *Understanding Media: The Extensions of Man* (New York: The New American Library, Inc., 1964), 23.

3. Jacques Derrida, *Of Grammatology*, trans. Gayatri Chakravorty Spivak (Baltimore: The Johns Hopkins University Press, 1974).

4. Clement Greenberg, *Art and Culture: Critical Essays* (Boston: Beacon Press, 1961), 10.

5. Roberta Smith, "Rituals of Consumption" *Art in America* 76, no. 5 (May 1988): 170.

6. Robert Storr, "An Interview with Mike Kelley" *Art in America* 82, no. 6 (June 1984): 91.

7. Michael Duncan, "Kelley's Junk-Shop Pop" *Art in America* 82, no. 6 (June 1984): 88.

8. Adrian Dannatt, "Damien Hirst: Life's Like This, Then It Stops" *Flash Art* 26, no. 169 (March/April 1993): 63.

9. Ibid., 62.

10. Alexander Alberro, "An Interview with Kara Walker" in *Kara Walker: Upon My Many Masters – An Outline* (San Francisco: San Francisco Museum of Modern Art, February 14-May 13, 1997), n.p.

11. Ibid.

12. Ibid.

13. Sydney Jenkins, "Interview with Kara Walker" in *Look Away! Look Away! Look Away!* (Annandale-on-Hudson, New York: Center for Curatorial Studies, Bard College, September 23-October 22, 1995), 11.

14. Alberro, "An Interview with Kara Walker," n.p.

15. Jérôme Sans, "Matthew Barney: Modern Heroes" *art press* no. 204 (July/August 1995), p. 28.

16. Ibid., 31.

17. Ibid.

1. **Cindy Sherman**, *Untitled #153* from the *Fairy Tales* series, 1985

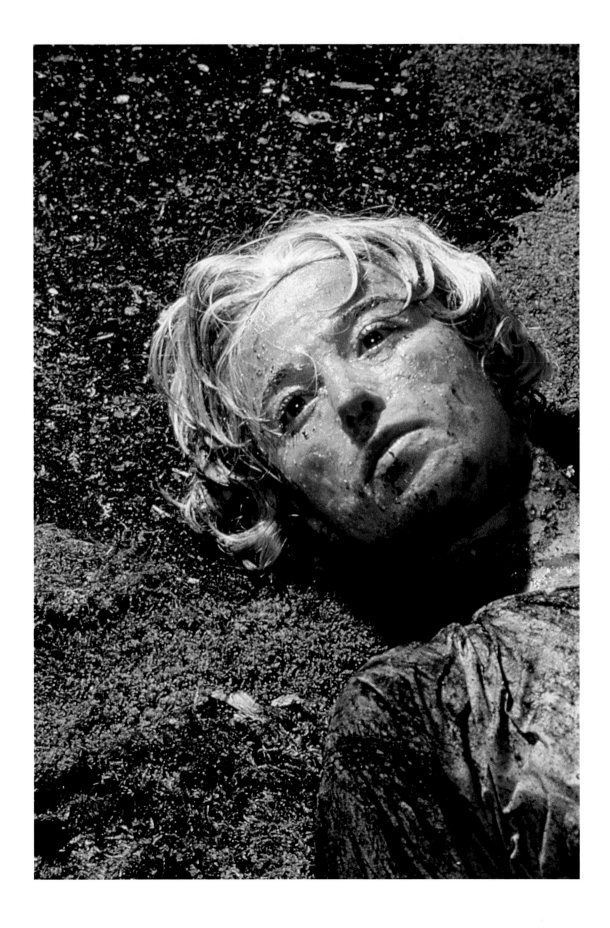

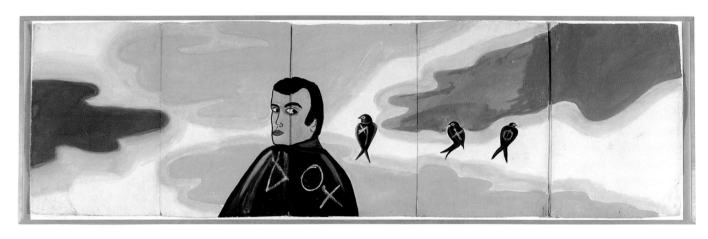

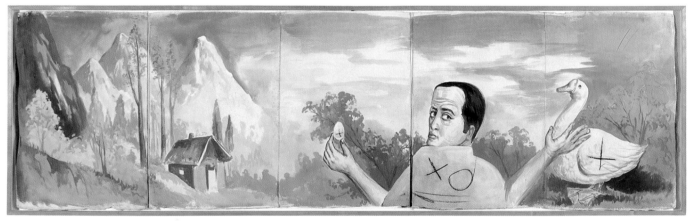

2. **Francesco Clemente**, *Untitled*, 1980

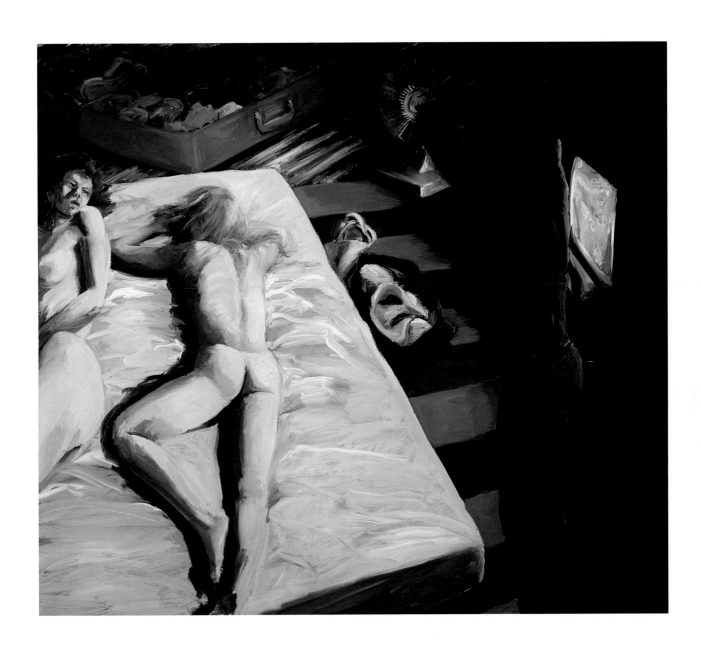

3. **Eric Fischl**, *The Visit II*, 1981

4. **Jean-Michel Basquiat**, *Wicker*, 1984

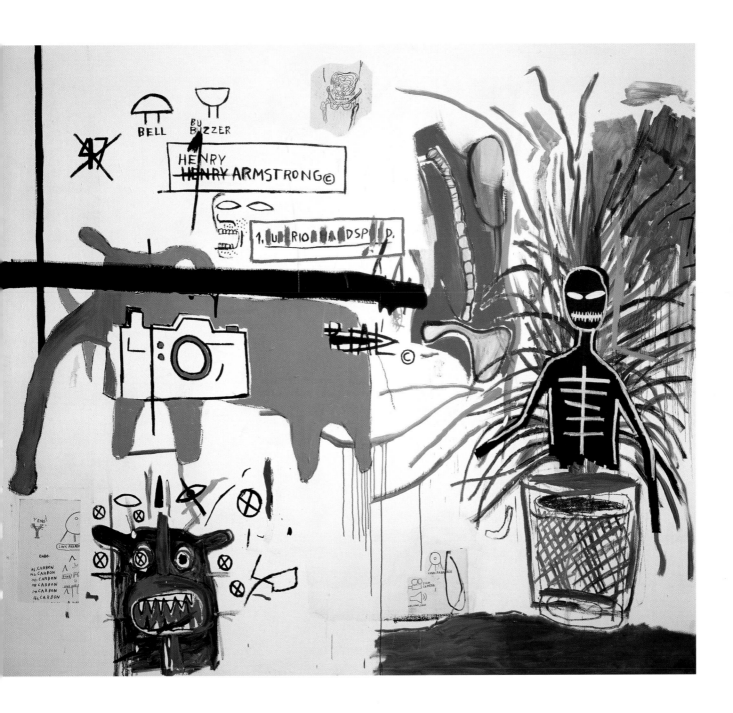

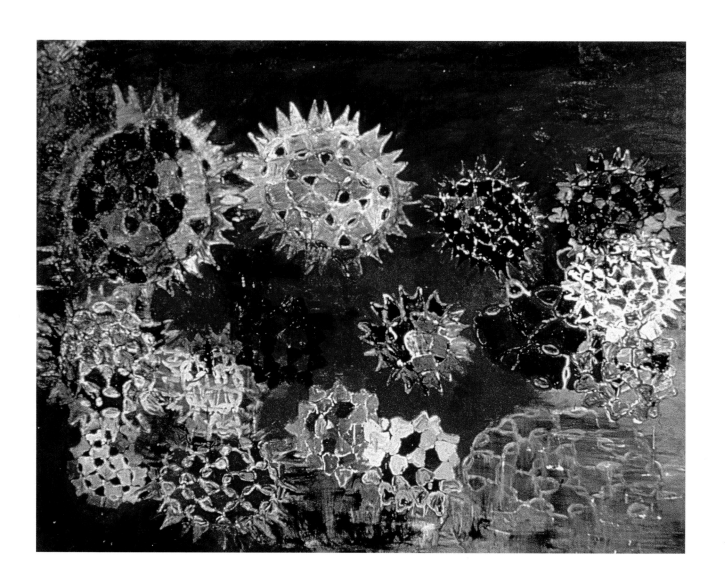

5. **Terry Winters**, *Tracer*, 1984

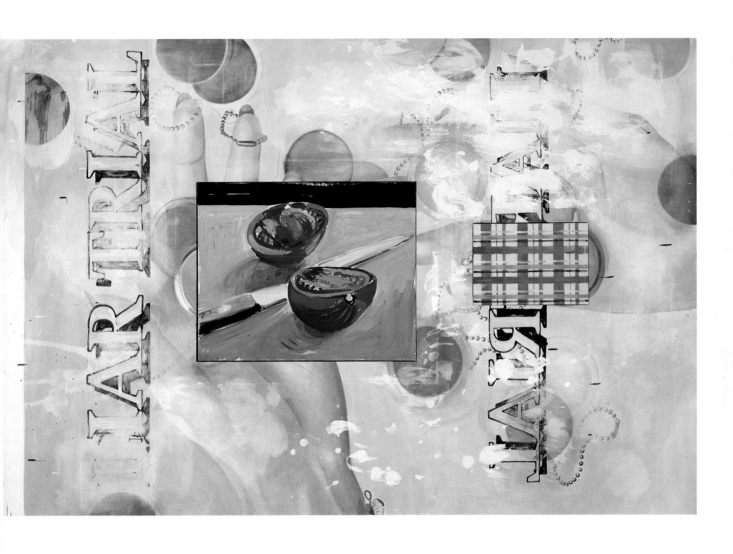

6. **David Salle**, *Tomato and Plaid*, 1997

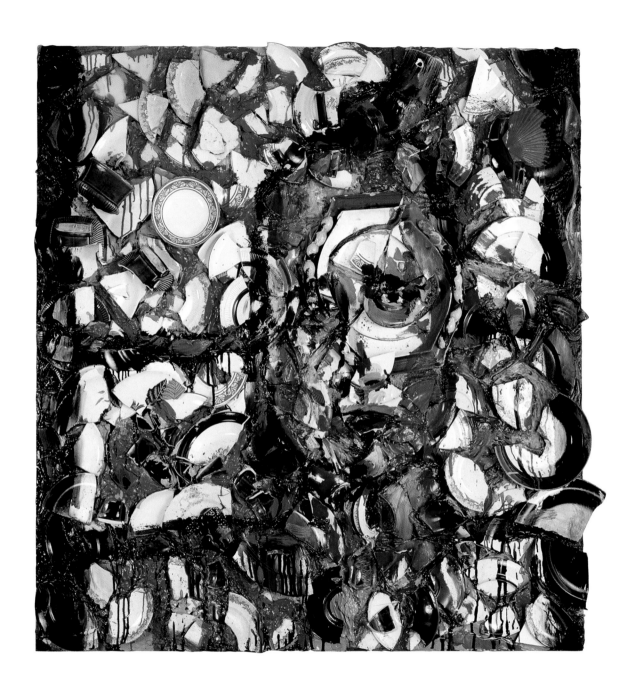

7. **Julian Schnabel**, *Ross*, 1983-84

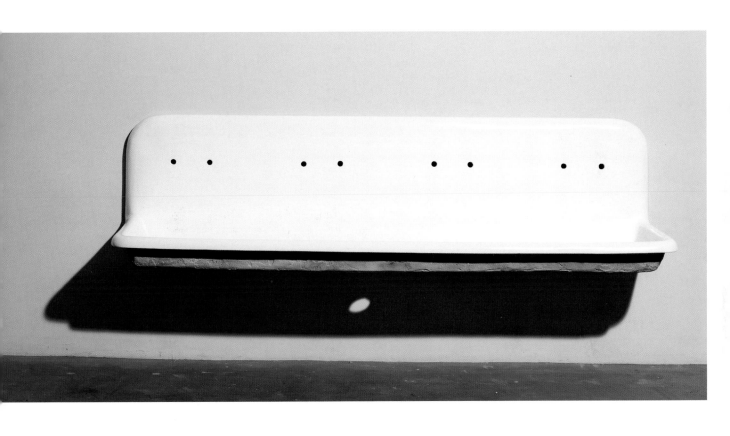

8. **Robert Gober**, *Long Sink*, 1985

9. **Jeff Koons**, *Rabbit*, 1986

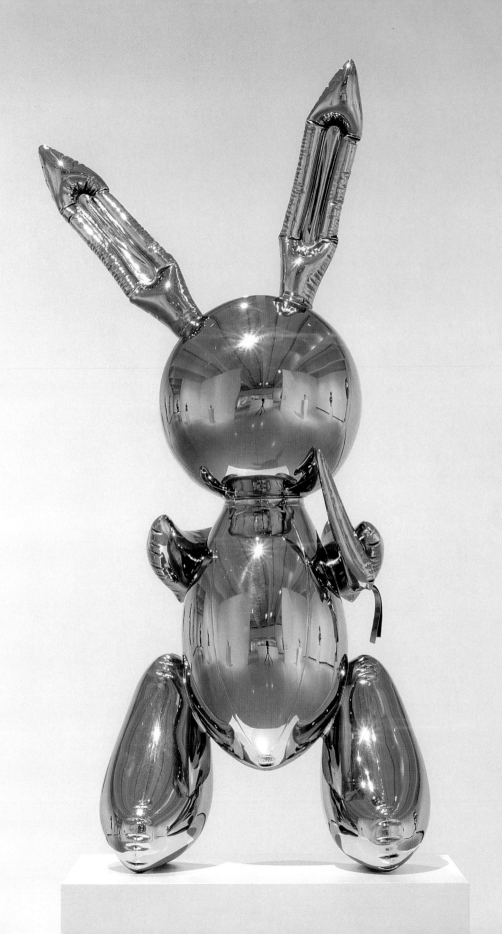

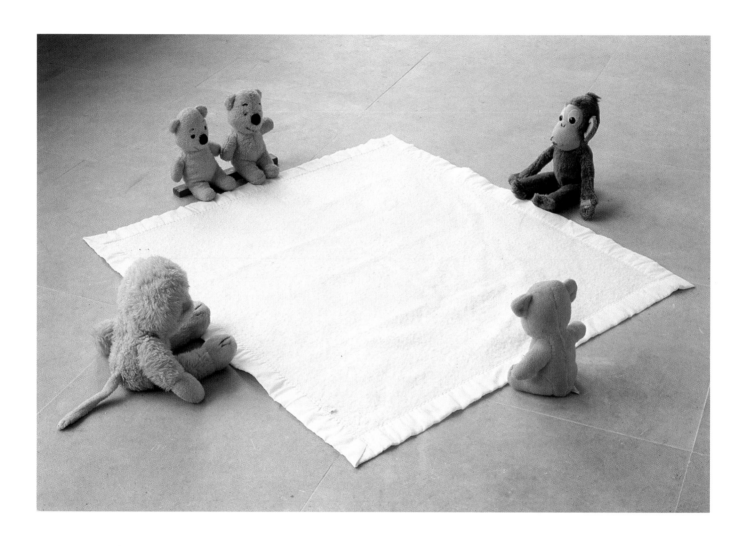

10. **Mike Kelley**, *Arena #7*, 1990

11. **Charles Ray**, *No*, 1992

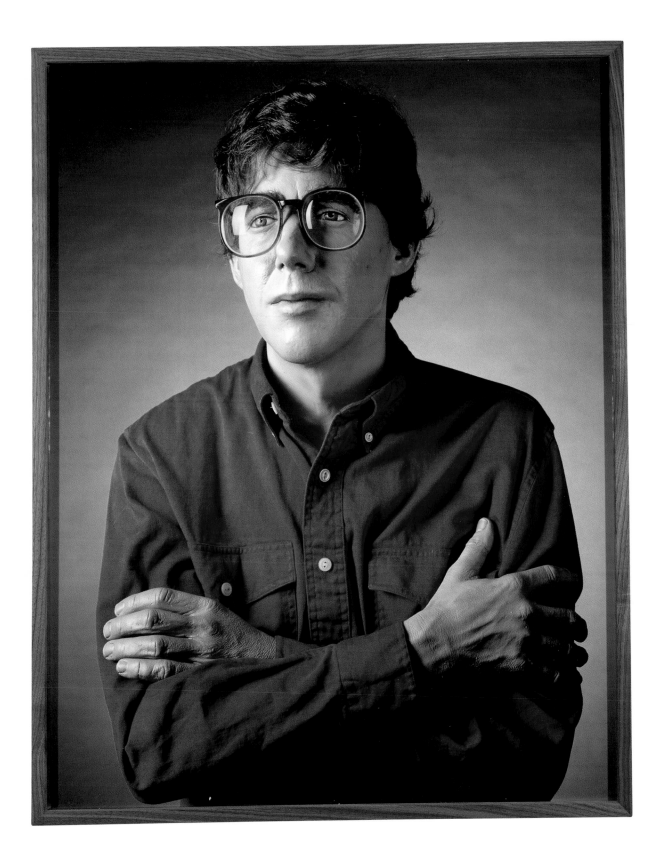

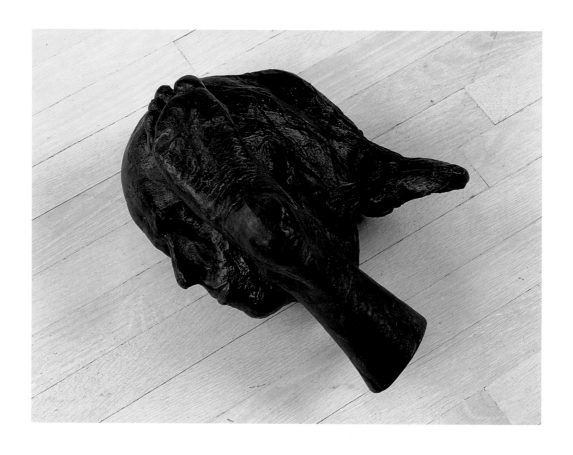

12. **Kiki Smith**, *Untitled*, 1992

13. **Julio Galán**, *Jueves*, 1995

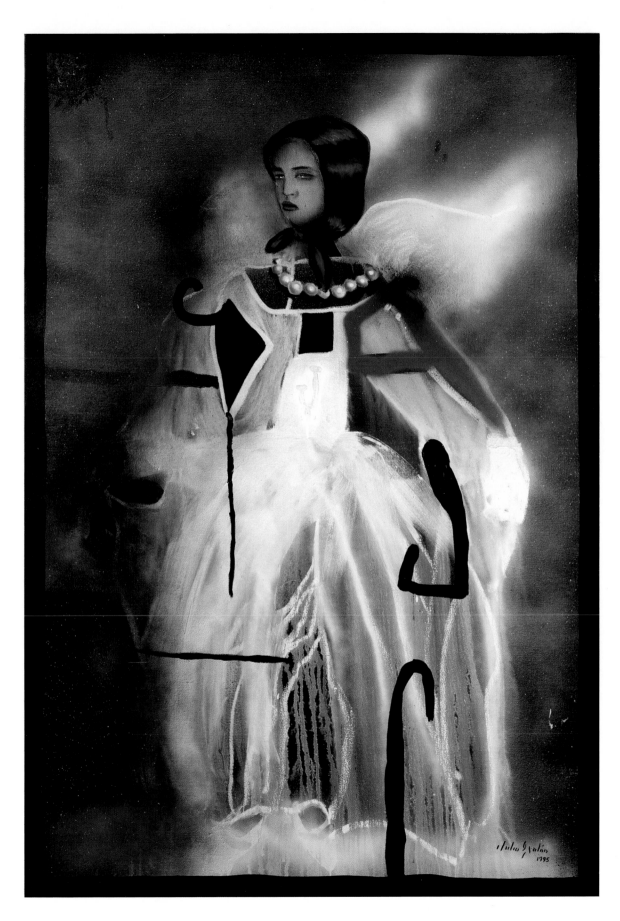

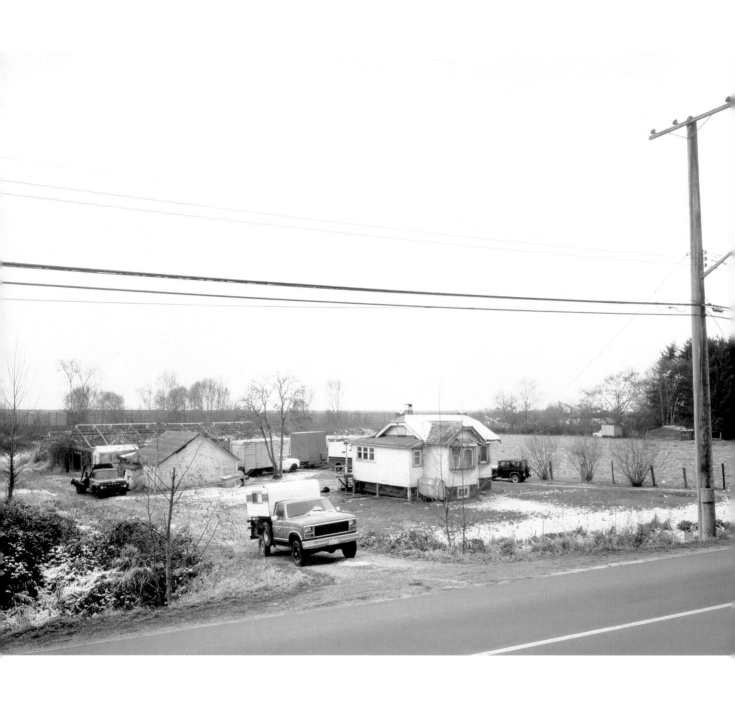

14. **Jeff Wall**, *17340 River Road, Richmond, B.C., Winter 1994*, 1995

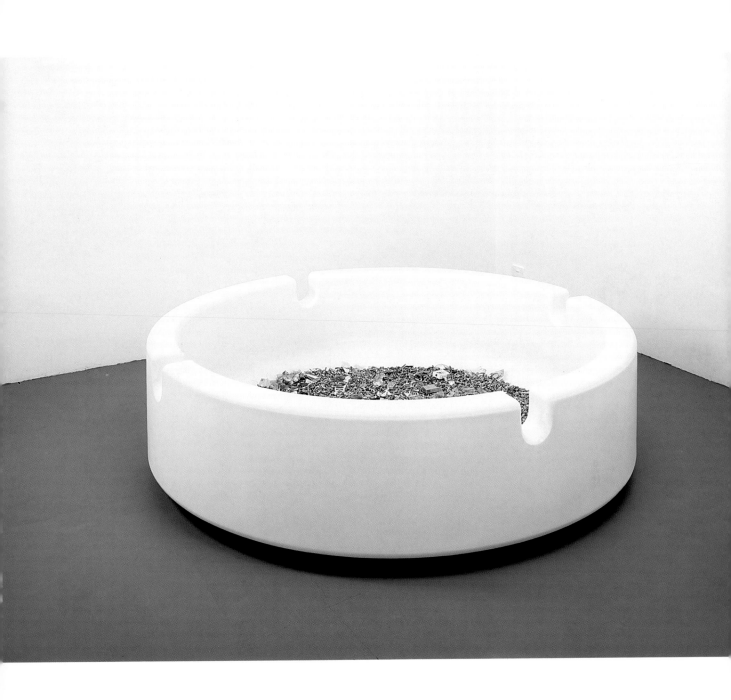

15. **Damien Hirst**, *Party Time*, 1995

16. **Kara Walker**, *De Flower of Georgia*, 1996.

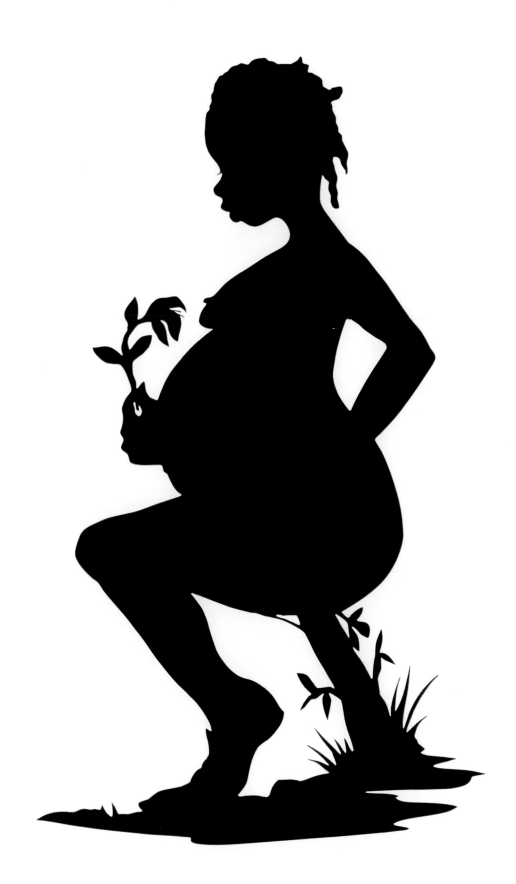

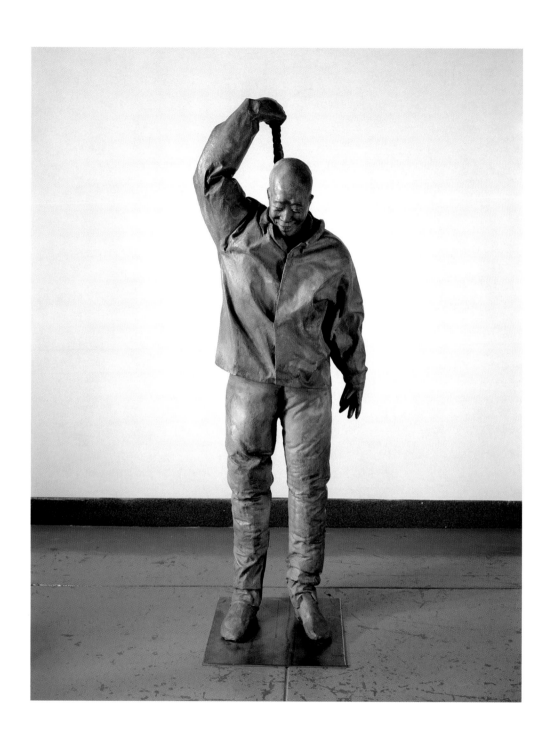

17. **Juan Muñoz**, *Chino con Coleta I*, 1997

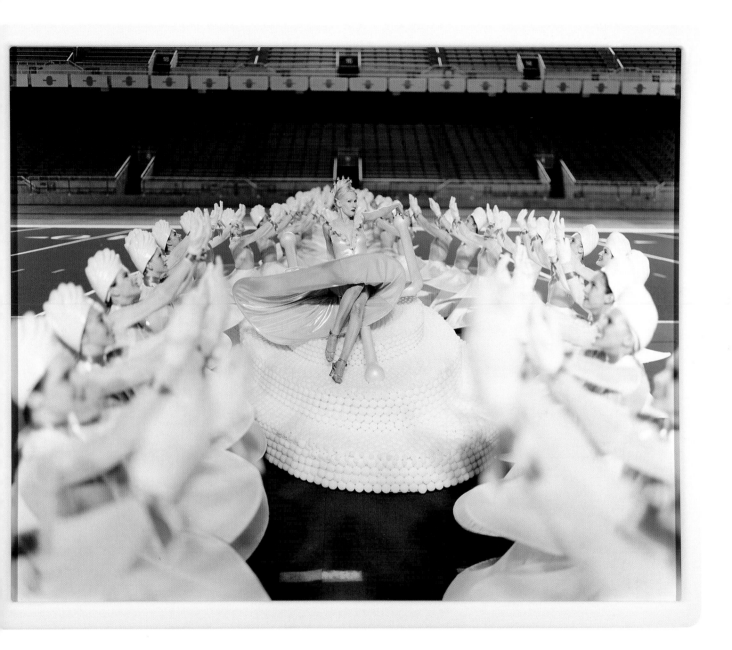

18. **Matthew Barney**, *Cremaster 1: Goodyear Chorus*, 1995

19. **Andreas Gursky**, *Chicago Board of Trade*, 1997

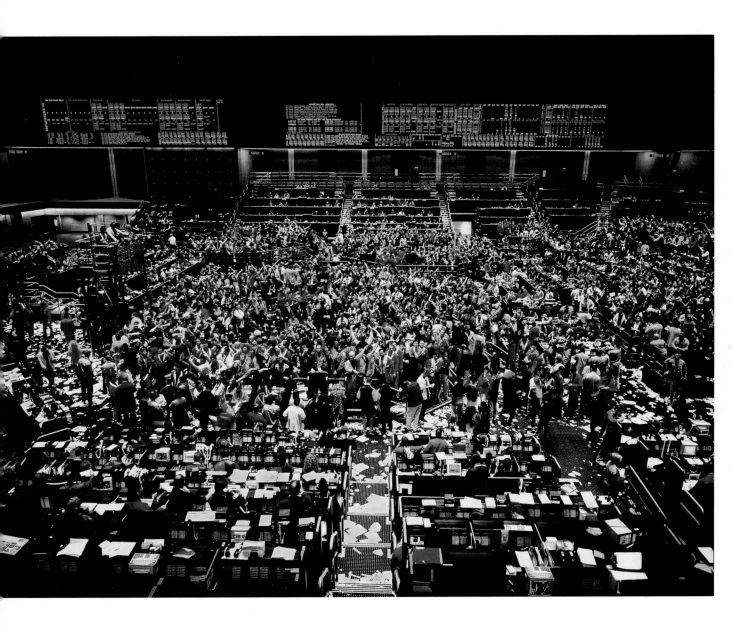

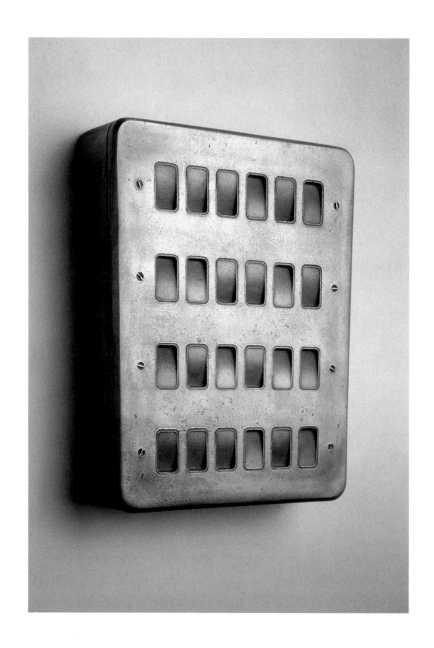

20. **Rachel Whiteread**, *Untitled (Twenty-Four Switches)*, 1998

## Checklist

**Matthew Barney**
*Cremaster 1: Goodyear Chorus*
1995
C-print in self-lubricating plastic frame
$43^3/_4$ x $53^3/_4$ inches
Refco Group, Ltd., Chicago
Photo: Michael Tropea, Chicago

**Jean-Michel Basquiat**
*Wicker*
1984
oil on canvas
86 x 98 inches
Eli Broad Family Foundation,
Santa Monica

**Francesco Clemente**
*Untitled (diptych)*
1980
charcoal and pastel on paper
each: 33 x 111 inches
Rubell Family Collections

**Eric Fischl**
*The Visit II*
1981
oil on canvas
68 x 78 inches
Collection Emily & Jerry Spiegel

**Julio Galán**
*Jueves*
1995
oil on canvas
75 x 51 inches
Collection Evan and Mary Tawil,
New York

**Robert Gober**
*Long Sink*
1985
plaster, wire lathe, wood, steel, semi-gloss
enamel paint
25 x 96 x 23 inches
Collection Jill and Jay Bernstein
Photo courtesy Shoshana Wayne Gallery,
© Douglas M. Parker Studio, Los
Angeles

**Andreas Gursky**
*Chicago Board of Trade*
1997
C-print
$70^7/_8$ x $94^1/_2$ inches
Collection Dennis and Deborah Scholl

**Damien Hirst**
*Party Time*
1995
plastic resin, foam, cigarette butts
and debris
96 inch diameter
Collection of the Denver Art Museum;
Funds from Colorado Contemporary
Collectors: Suzanne Farver, Linda and
Ken Heller, Jan and Frederick Mayer,
Beverly and Bernard Rosen, and Annalee
and Wagner Schorr, from the 1985
and 1986 Alliance for Contemporary
Art Auctions by Exchange, and from
anonymous donors; 1996.81
Photo courtesy Gagosian Gallery

Mike Kelley
*Arena #7*
1990
found materials, stuffed animals,
wood, blanket
11¹/₂ x 53 x 49 inches
Skarstedt Fine Art, New York

Jeff Koons
*Rabbit*
1986
stainless steel
41 x 19 x 12 inches
Stefan T. Edlis Collection

Juan Muñoz
*Chino con Coleta I*
1997
bronze
60 x 20 x 14 inches
Collection Nancy and Bob Magoon
Photo courtesy Marian Goodman
Gallery; by Cathy Carver, New York

Charles Ray
*No*
1992
C-print
38 x 30 inches
Refco Group, Ltd., Chicago
Photo: Michael Tropea, Chicago

David Salle
*Tomato and Plaid*
1997
oil and acrylic on canvas
64 x 96 inches
Collection Susan and Larry Marx
Photo courtesy The Baldwin Gallery

Julian Schnabel
*Ross*
1983-84
oil, plates, bondo on wood
45 x 48 inches
Collection Linda and Bob Gersh,
Aspen, Colorado
Photo courtesy Daniel Weinberg Gallery

Cindy Sherman
*Untitled #153 from the "Fairy Tales" series*
1985
color photograph
67 x 49¹/₂ inches
Skarstedt Fine Art, New York

Kiki Smith
*Untitled*
1992
cast bronze
7 x 12 x 15 inches
Collection Jill and Jay Bernstein
Photo © Oren Slor

Kara Walker
*De Flower of Georgia*
1996
cut paper and wax adhesive
47 x 28 inches
Collection Nancy and Bob Magoon

Jeff Wall
*17340 River Road, Richmond, B.C.,
Winter 1994*
1995
cibachrome transparency, aluminum
lightbox, fluorescent lamp
41³/₈ x 52³/₄ x 9⁷/₈ inches
Collection Nina and Frank Moore

**Rachel Whiteread**
*Untitled (Twenty-Four Switches)*
1998
aluminum
$10^{1}/_{4}$ x 8 x $2^{3}/_{8}$ inches
Collection Rosina Lee Yue and
Bert A. Lies, Jr., M.D.
Photo courtesy Luhring Augustine,
New York

**Terry Winters**
*Tracer*
1984
oil on canvas
81 x 104 inches
The Eli Broad Family Foundation